kaleidomorphia

LOM ART

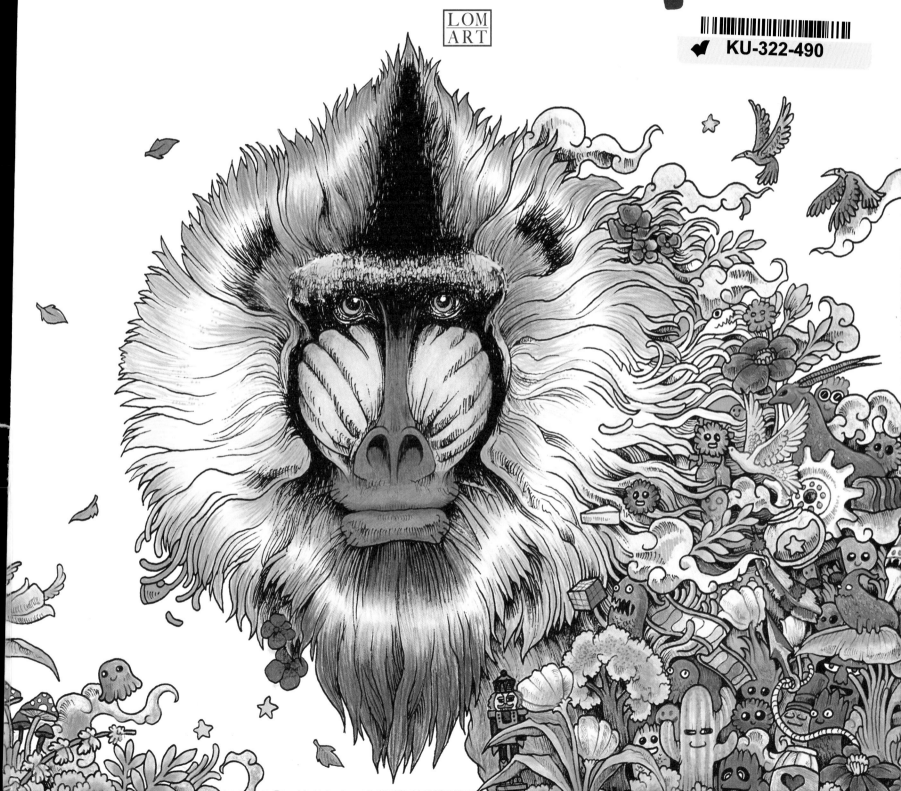

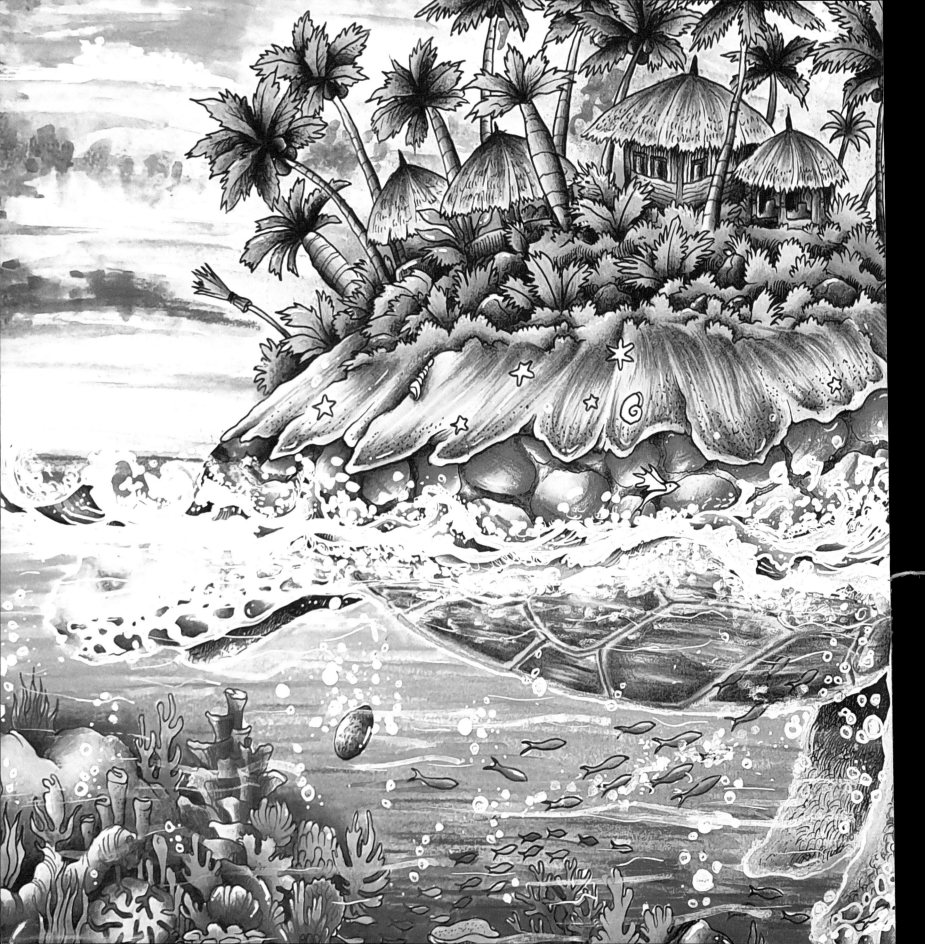

Colour, Morph, Create

Dive in to my doodle world, where animals and mythical creatures come to life, otherworldly beings morph out of landscapes and fantasy melts into reality.

In this book, you'll find images by some incredibly talented colourists, who have used a kaleidoscope of colour to complete artwork from my **morphia** series. Discover their colour palette choices, blending and shading techniques, additions and innovations, and pick up some tips and tricks that you can use in your own masterpieces. You can also read my impressions of each finished piece, which explore what makes each colourist's treatment work so well.

These pictures, as well as a selection of my favourite pieces from across the series, appear in the colouring section so you can complete them with your own choice of bright and beautiful colours.

I hope you get inspired and enjoy bringing my intricate illustrations to life with your own kaleidoscope of colour.

Kerby Rosanes

Tropical Turtle (this page) coloured by Victoria Wittmann a.k.a @coloringwithvicky

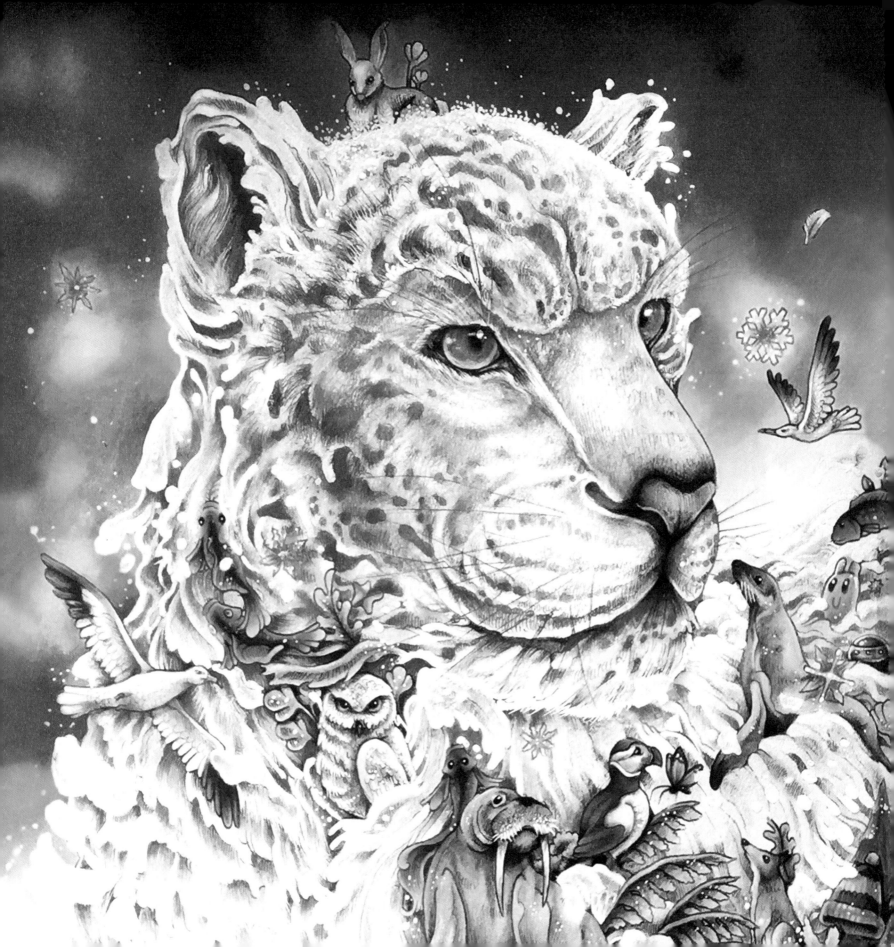

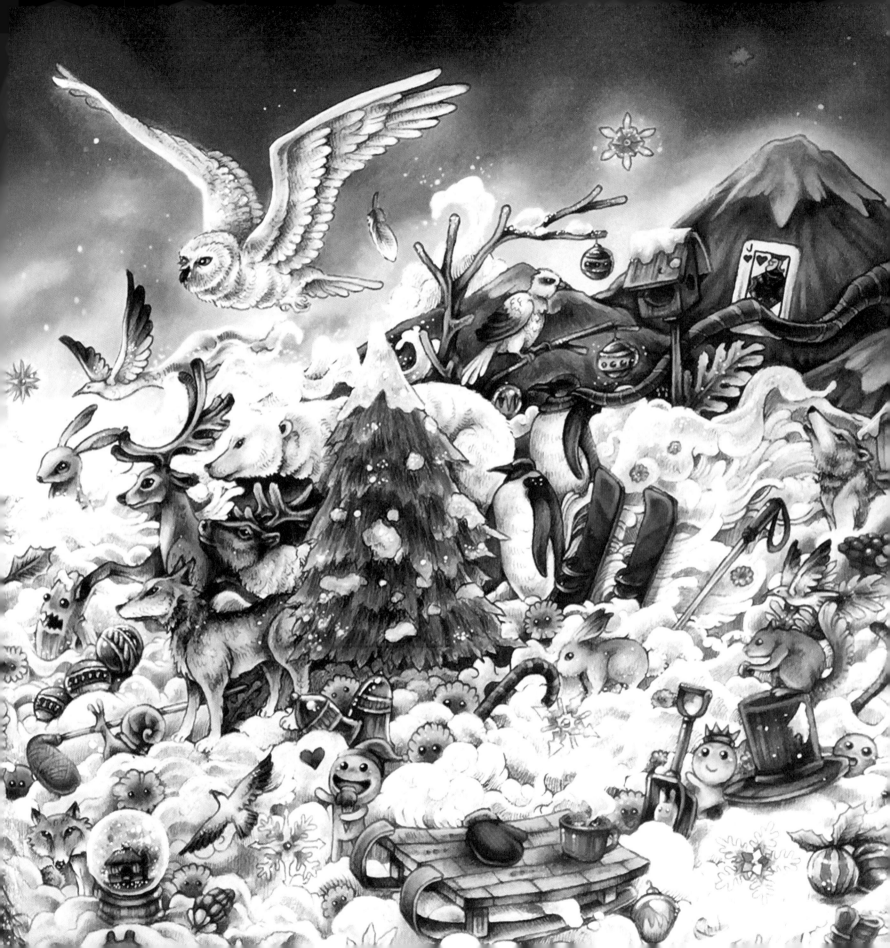

Spirit Snow Leopard – Blending the Realistic and the Magical (previous page)
Coloured by Nadia Mejri a.k.a @clannadia

This colourist has used a striking selection of colours for the background, blurring fuchsia pinks, powerful purples and creamy yellows together to create a magical effect, visually similar to an aurora. She has achieved a colourful and bright background that contrasts with the white of the snow leopard.

Much of the leopard has been coloured in subtle, pastel hues, using delicate shading to give the impression of texture and to create realistic-looking markings on its fur. The lilac-grey tones beautifully complement the purples in the sky, mountains and trees. Blending from dark to light tones is achieved by gradually layering colour using high-quality pencils.

The outer fur has been made to appear like folds of melting snow, with white flurries splashing off its body. The winter creatures bounding out of the snow leopard's fur have been coloured with a realistic palette and intricate shading to bring the animals to life.

An element of opposition and contrast comes into play with the selection of colours for the alien creatures. Acidic greens and yellows make them stand out against the more camouflaged winter creatures.

The overall visual effect achieved is a masterful blending of realistic and magical elements, bringing the world of spirit and fantasy together with the real-life animal kingdom.

Castle in the Clouds – Achieving Fantasy Through Innovation (facing page)
Coloured by Angeline Black a.k.a @angelineblack2020

Building on the fantastical theme, this colourist has used her own artistic talent and innovation to create a breathtaking, magical scene. The background is a striking example of how additions to the artwork can amplify the drama of an image. The colourist has drawn her own planets with realistic colours. She has used blending on the planets' surfaces which, combined with the lighter tones on the outer edges, work together to create a reflective glow.

The textured detail within the clouds is entirely of the colourist's own creation. Pastel-toned shadows and highlights contrast the jewel-toned background. The addition of stars in carefully selected places draws the eye to key features, such as the dragons, planets and tall towers of the castle.

The colourist has chosen analogous colour combinations for the background, beginning with indigo blue and moving to a glowing yellow. This creates a rich and striking backdrop for the mystical castle. Narratively, this colour choice suggests a move from the night sky to the colours of dawn. Colour theory can be used to find the perfect combination for any desired effect.

The castle itself shows further features of innovation. The gold, metallic effect of the crescent moon is created by the colourist's choice of varying yellow and bronze tones. Matching the yellow behind the glowing clouds with the brightest tones of yellow on the moon and in the castle windows, gives the illusion of light shining from these surfaces. These warm tones are set against the icy-blue tones of the castle walls and steps, giving further depth and dimension to the scene.

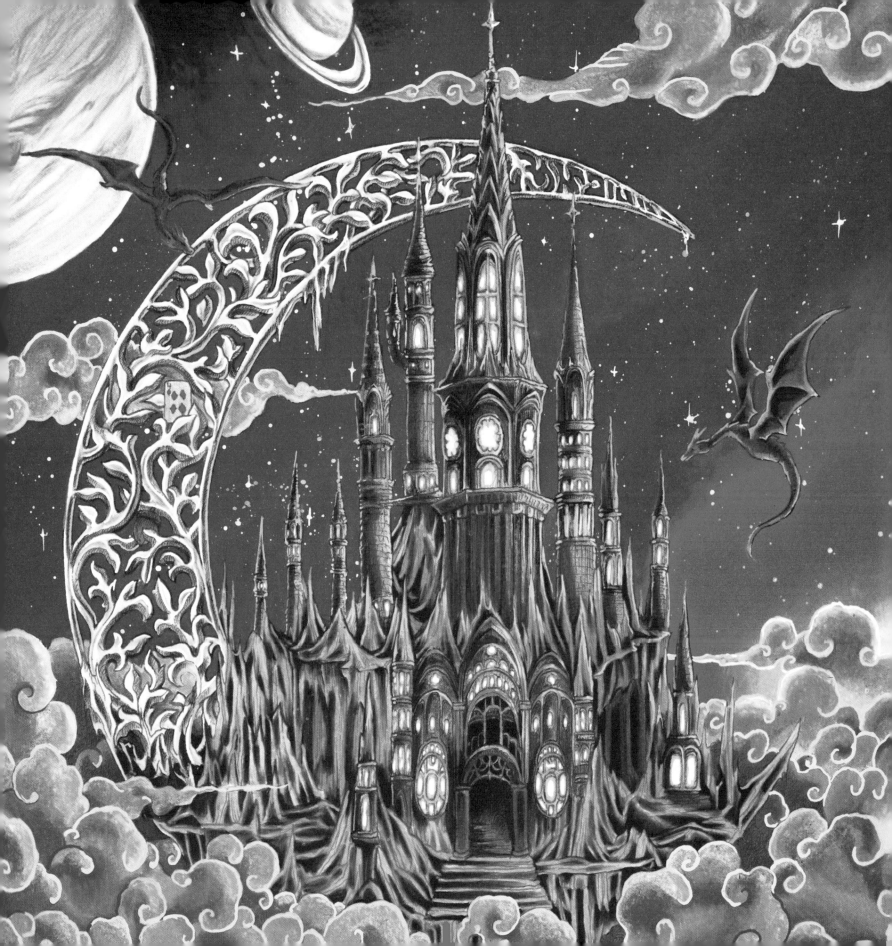

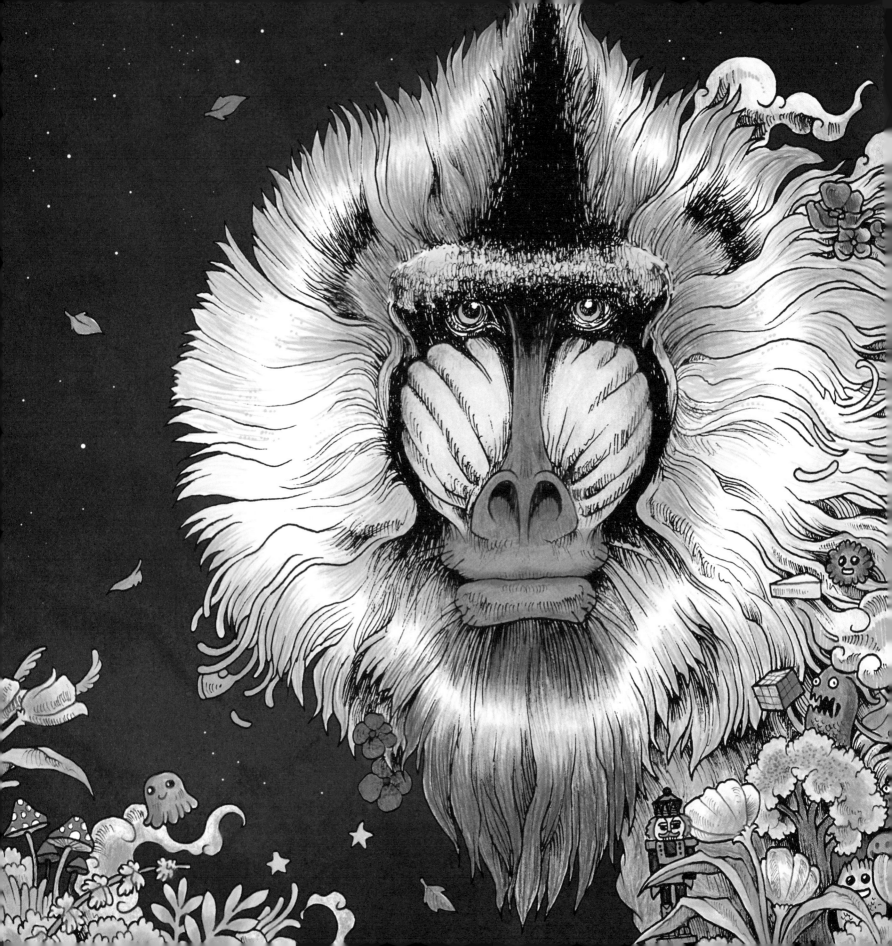

Kaleidoscopic Mandrill – A Rainbow Spectrum Composition (previous page)
Coloured by Lauren Farnsworth

This colourist has used the colours of the rainbow spectrum to create a feast for the eyes. She has chosen a rich, night-sky background which enables the vibrant colours to pop. The mandrill vibrates against an inky black backdrop.

As very dark colours can be challenging to render by hand, the colourist has added the background digitally. This ensures a tone of enough depth to allow the main image to leap off the page.

The colourist uses a full spectrum of colour variation in the individual elements, demonstrating her great technical skill. She achieves a wonderfully playful aesthetic by using a mix of contrasting and complementary tones to create a bright and busy doodle scene.

For the mandrill's mane, the colourist has gradually blended from warm to cool colours. She has used impressive shading and highlights to create a realistic shine effect, which adds texture and dimension to this truly kaleidoscopic creature.

Elephant Enchantment – Making Waves With Acrylics (facing page)
Coloured by Élodie Petit a.k.a @les_colo_de_elow

The striking shading and the azure-blue tones used by this colourist give the impression of a creature formed out of water. The waves seem to flow off the elephant's tail and body. Using darker navy tones to contrast with the pale blues adds an impressive sense of depth. The colourist is playing with water, earth and air elements to reinforce the magical theme.

The image has a painterly feel. The strong, pigmented vibrancy of the colours has been achieved with acrylic paints. In using black paint to colour the background, the colourist has created a rich and stark backdrop, ensuring the brighter elements pop off the page.

She has used cool green and rich turquoise acrylic paint pens for the outlines of the leaves and to colour the clouds. Her decision to use silver and gold in the tusks, headpiece and claws adds to the dramatic and regal aesthetic of the subject.

One of the most striking features is the luminous white outline of the elephant. This glowing neon effect can be achieved by using white acrylic markers of different sizes. The colourist has used fine and wider points for varying degrees of detail.

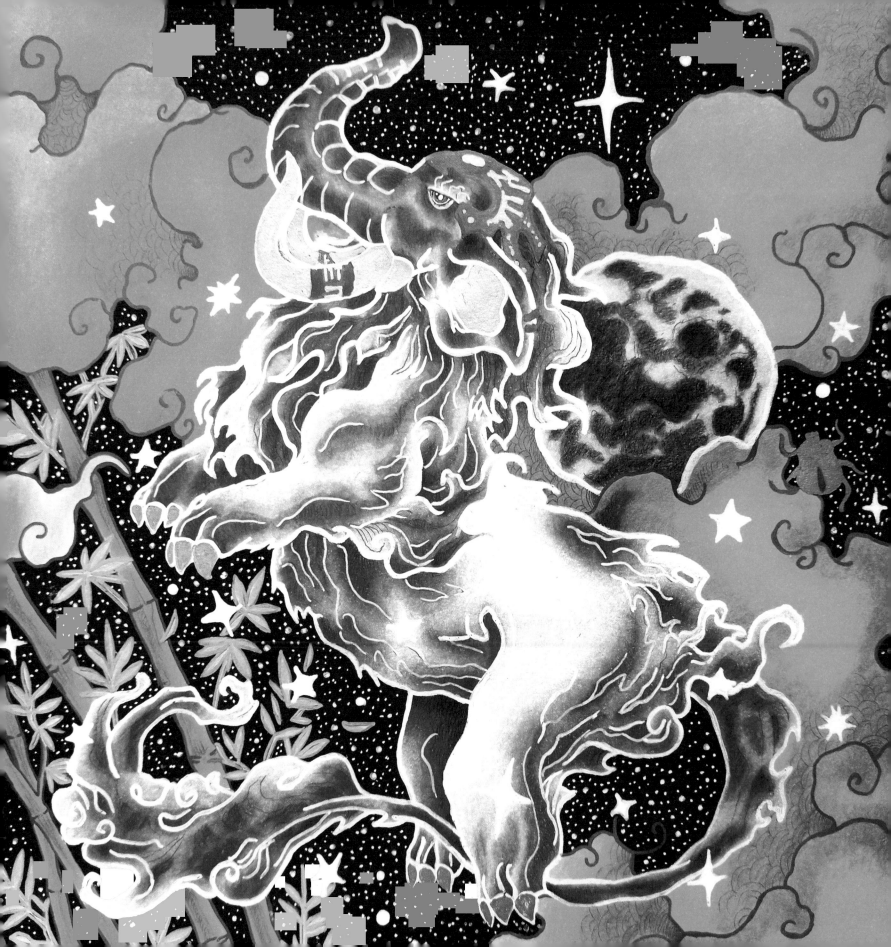

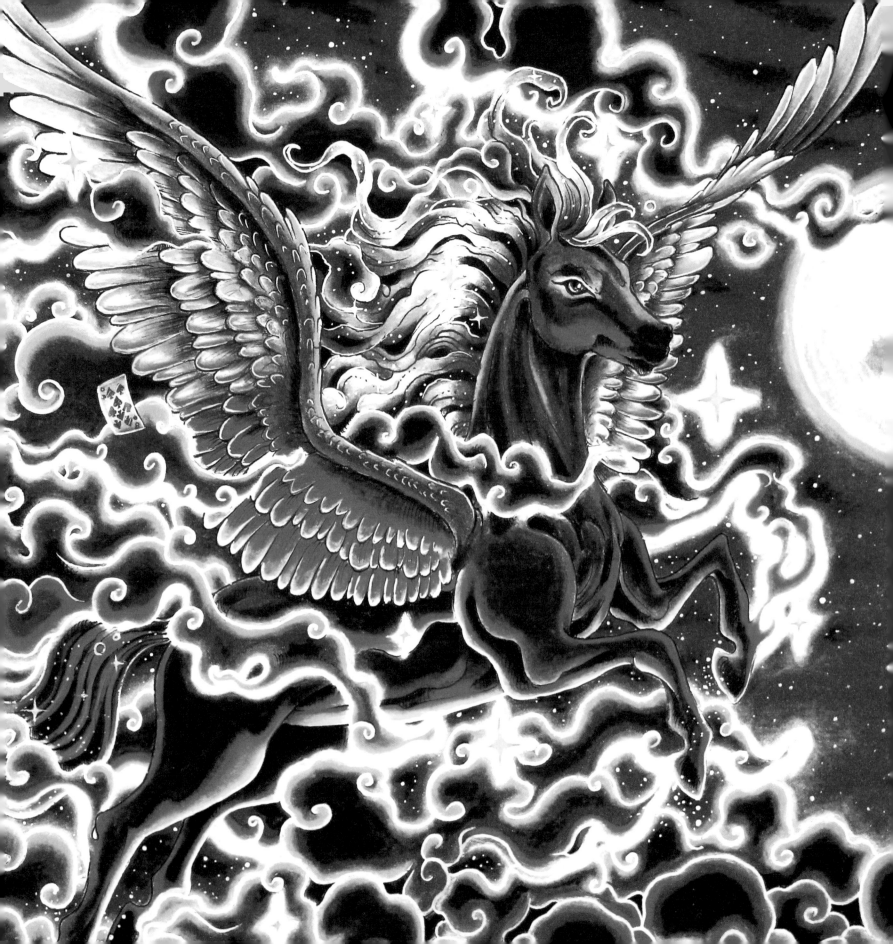

Pegasus Power – Achieving a Neon Glow (facing page)
Coloured by Yekaterina Zhunusbayeva a.k.a @katerina.zhunusbayeva

The glowing light that radiates from this image takes my breath away. By blending blue and yellow tones over the lines and tracing the border with a white gel pen, the colourist has achieved a striking lightness. Blurring colours outside the lines and then highlighting the line itself is also a clever way to add a three-dimensional effect to your artwork.

The dramatic contrast of light and dark tones also contributes to the luminous neon glow. The image features dramatic shading, with pockets of the deepest black used within the body of the creature and inside the clouds. This creates a fearless and powerful version of my Pegasus image.

The colourist has contrasted warm and cool tones to highlight certain areas. Using fiery reds, oranges and yellows on the bottom of the clouds and on Pegasus's body creates a sense of direction, as if the mythical creature is flying away from the sun and up towards the moon.

The colourist has used white paint to create the shine on the moon's surface and has blended pencils for its inner detail and glowing outline. Different materials achieve different striking visual effects, and this colourist has made impressive use of traditional colouring materials to achieve a unique and stunning piece.

Japanese Wave – Using Artistic Influences (next page)
Coloured by Virginie a.k.a @loucatvis

This colourist has created an outstanding artwork that draws on the characteristics of Japanese art, playing with Hokusai's famous woodblock print of the early 19th century, *The Great Wave*.

She has mirrored Hokusai's famous colour scheme. This restricted palette is typical of the genre, featuring varying shades of dusty blue to colour the wave that frames the scene. Drawing on famous art influences and emulating instantly recognizable techniques is a great way to anchor your artwork to a specific time, place or artistic style.

The pastel-blue tones that she has used to colour the sea foam, in contrast with the dark blues of the seawater, create a rich, watery texture and an added element of depth. This is achieved with watercolour pencils. She has disguised the bull-like creatures by colouring them with the same sea shades, also using a paint marker to trace the outline of the waves. This subtly adds to the drama of the image, as their features are revealed only when you look closer.

Balancing the cool blue tones and drawing on further Japanese stylistic influences, the colourist has used warm burgundy reds and sharp lines to form the sun. This is a feature which is entirely of her own invention. The sun acts as a focal point, drawing your eye to the centre created by the curling waves.

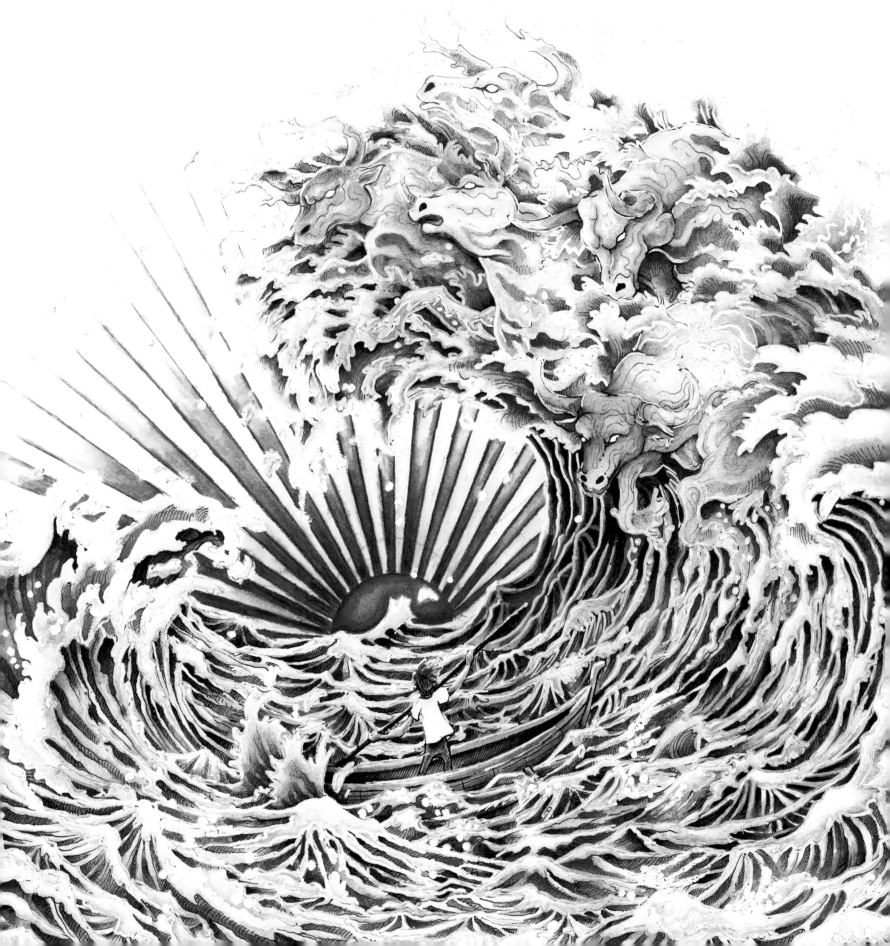

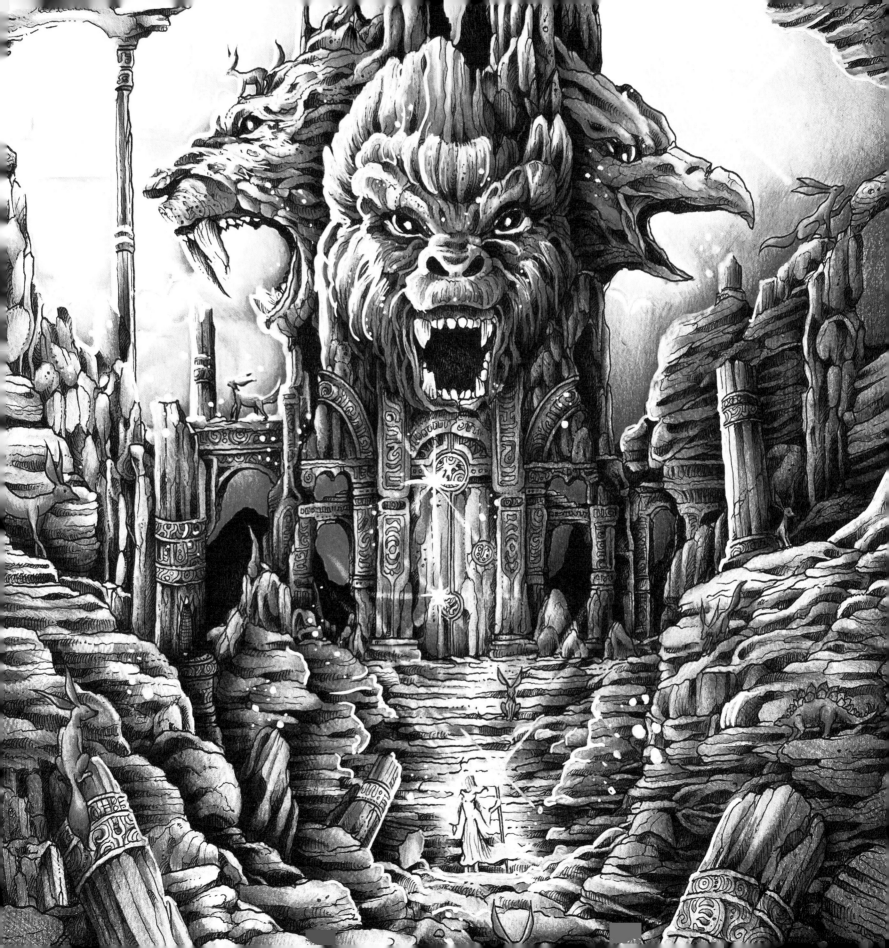

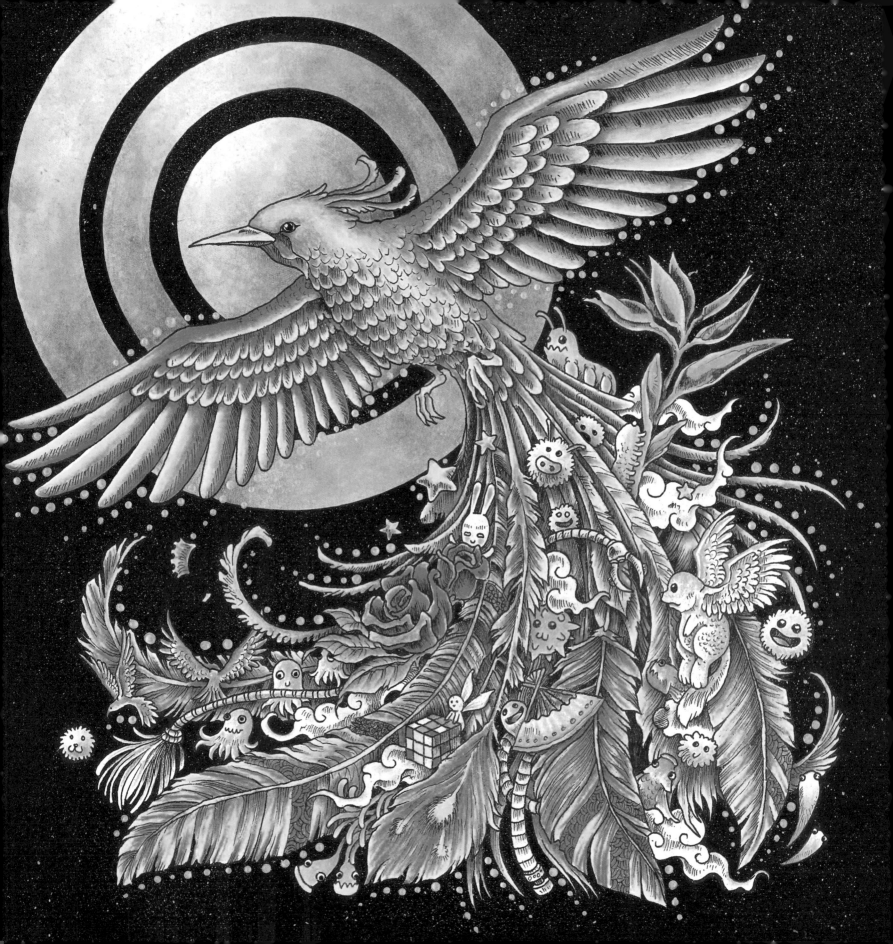

Lost Ruins – Lighting the Way With Colour (previous page)
Coloured by Laila Heldal a.k.a @colourwithlh

This striking image makes use of a bold yet restricted colour scheme, based around magenta and bright-yellow tones. The two colours are complementary hues, sitting opposite each other on the colour wheel. For the ominous sky and threatening faces of the creatures guarding the ruins, the colourist has chosen pinks and dark purples, which evoke a sense of mystery and threat. In contrast, the brighter yellows used for the figure approaching the ruins create the effect of light penetrating this dark fantasy world.

The colourist has continued this colour scheme to depict highlights and shadows. On the purple faces, yellow provides the highlights and on the golden ruins, purples and pinks provide the shadows.

The impressive lighting effects achieved by the colourist draw the eye to the figure and her staff. This becomes the focal point of the image, with rays of light bouncing off her and leading the eye to the doors ahead. You can use leading lines in your own work to guide your viewer's eye.

Starry detail in the sky, along with the white highlights on the creatures' faces and on the pathway below, further create the sense of reflection and luminosity. Overall, the colourist has created a captivating narrative of a figure of hope lighting a way through lost ruins.

Phoenix Reborn – A Lesson in Shapes and Symbolism (facing page)
Coloured by Reginaldo Brandao a.k.a @branddao.arts

This colourist has taken my illustration and confidently added his own elements, resulting in a striking phoenix image. A stunning night-sky effect has been created using a black water-based marker for the background, with additional specks of gold acrylic paint to represent stars. Using the bristles of a toothbrush, the colourist splashed the gold flecks on to the page to achieve this beautiful and unique effect.

He has used the fierce orange and yellow tones associated with the flames from which a phoenix emerges. The masterful blending of burnt orange tones to bright yellows gives the feathers depth. The bright and highly pigmented tones used in the bird's body contrast with the pastels in the circles behind it. These dusty tones were achieved using chalk. This contrast also ensures that the phoenix stands out as the picture's central focus. The colourist has used complementary blues and pinks to bring my doodles that morph out of the tail feathers to life.

The circles behind the bird act as a stylized sun and could also represent the life-cycle of the phoenix itself. A circle shape symbolizes immortality and rebirth throughout mythology, and this colourist's artwork references both these themes. The addition of dot work to frame the phoenix lends an extra playful interest to the bird, while enhancing a sense of motion and direction in its wings and tail feathers.

This is a stunning representation of the phoenix through colour, shapes and symbolism.

colouring section

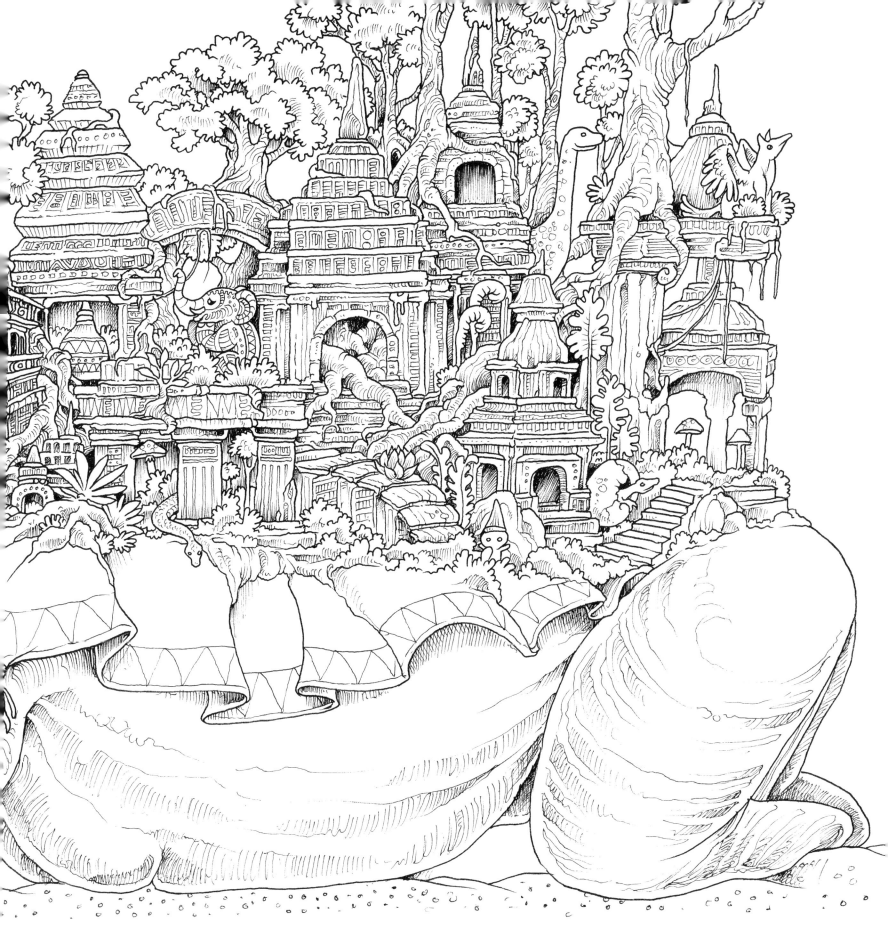

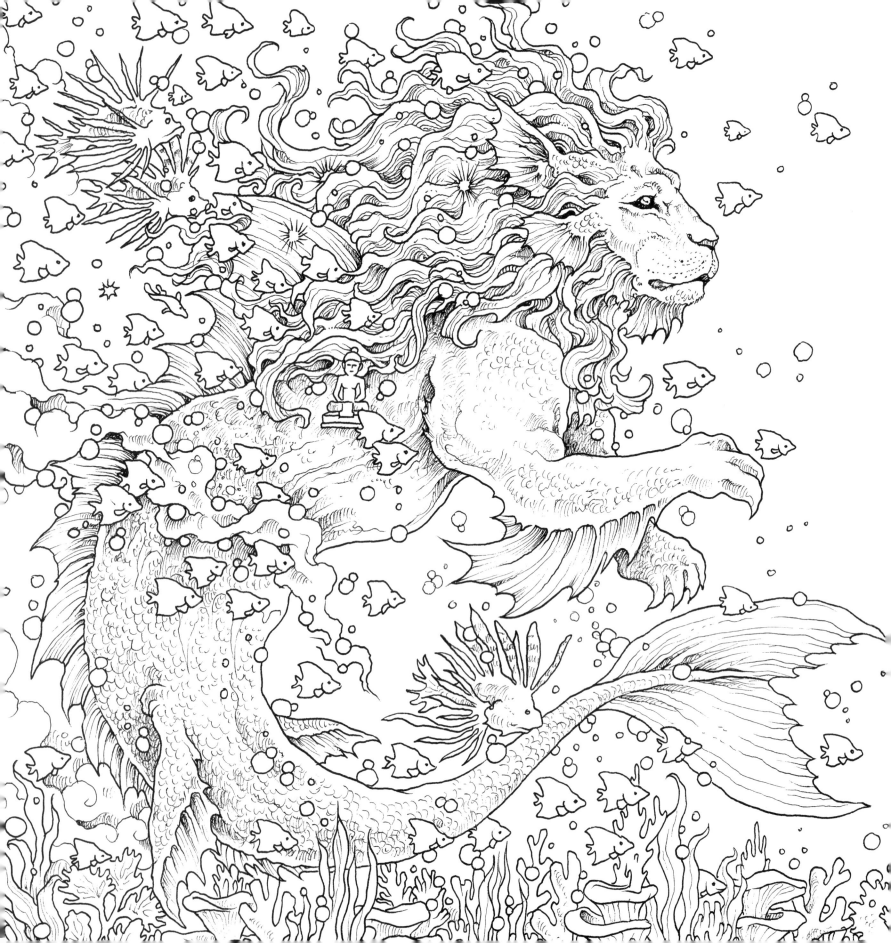

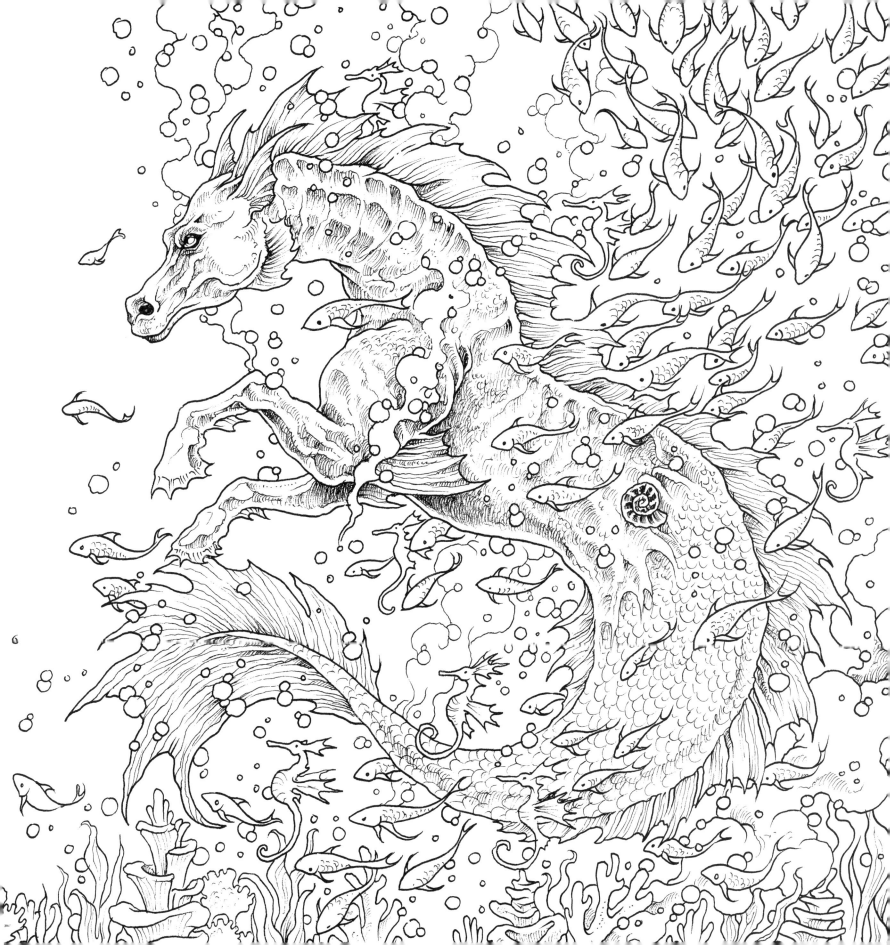

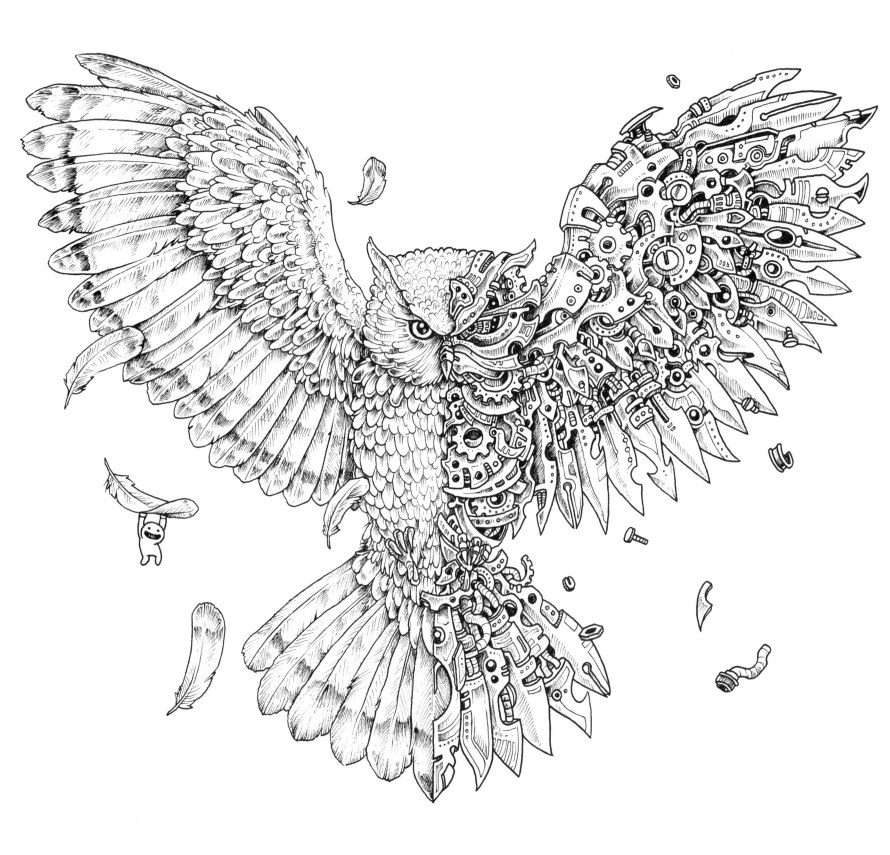

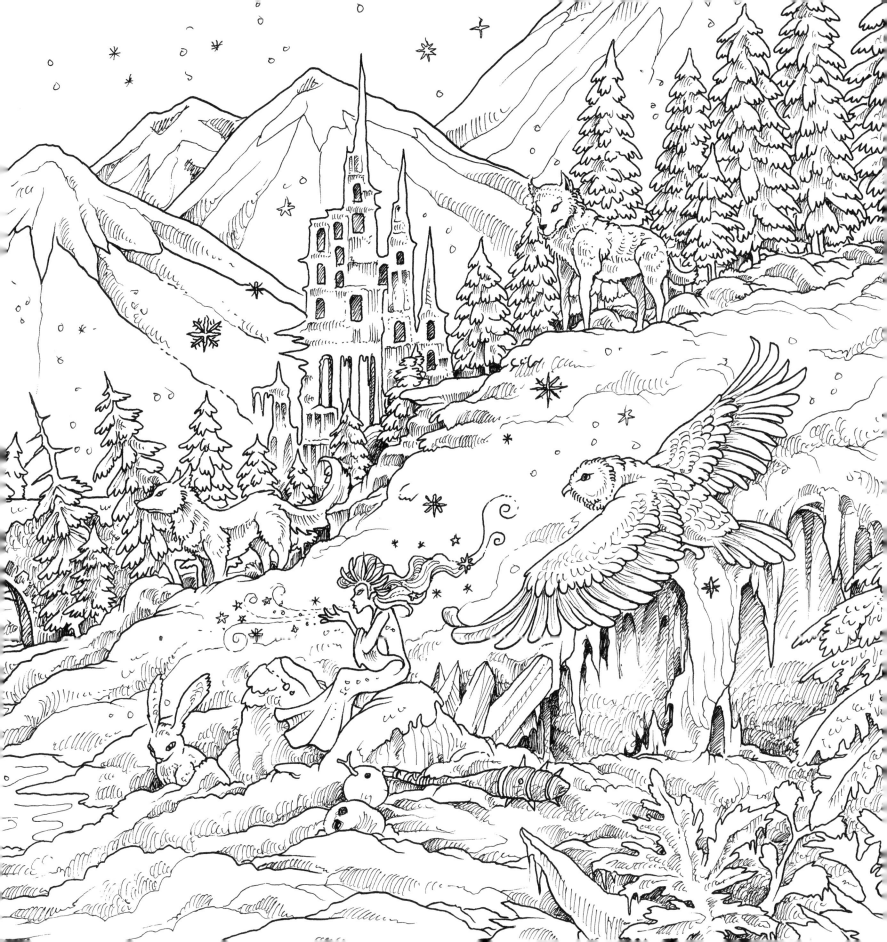

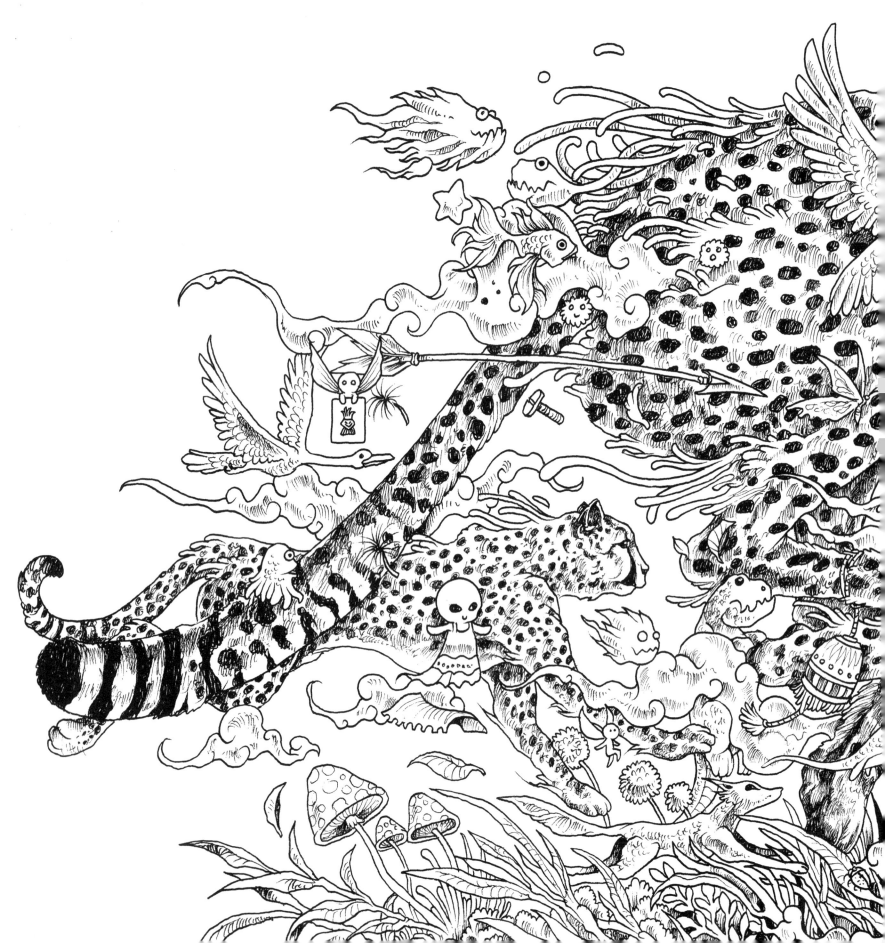

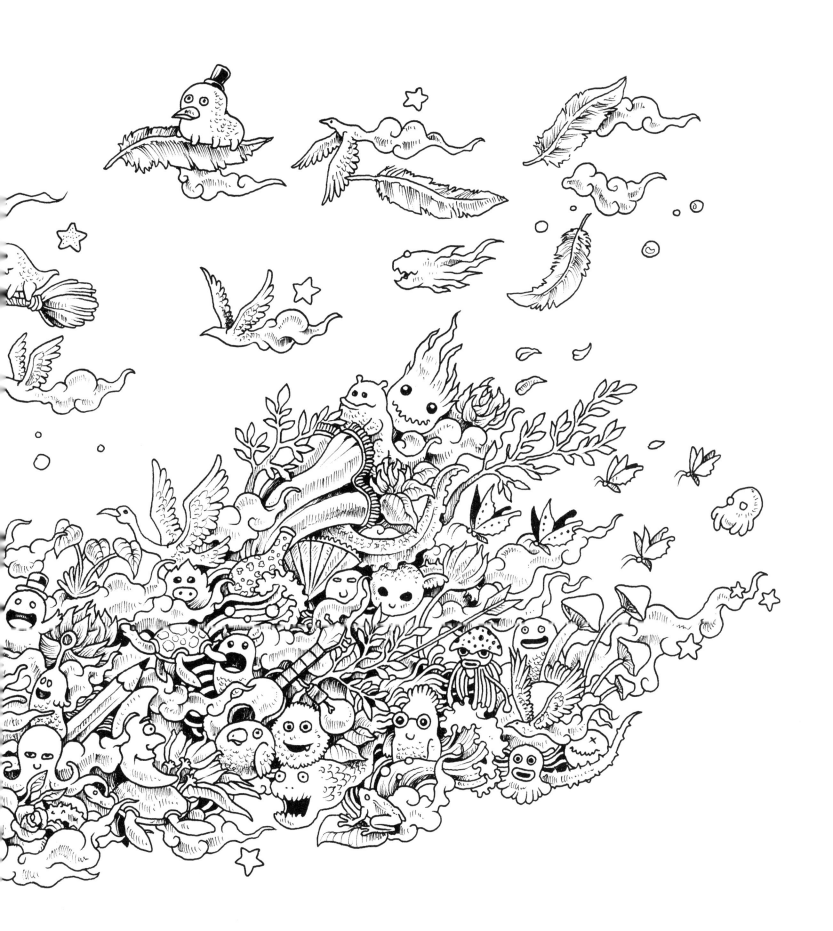

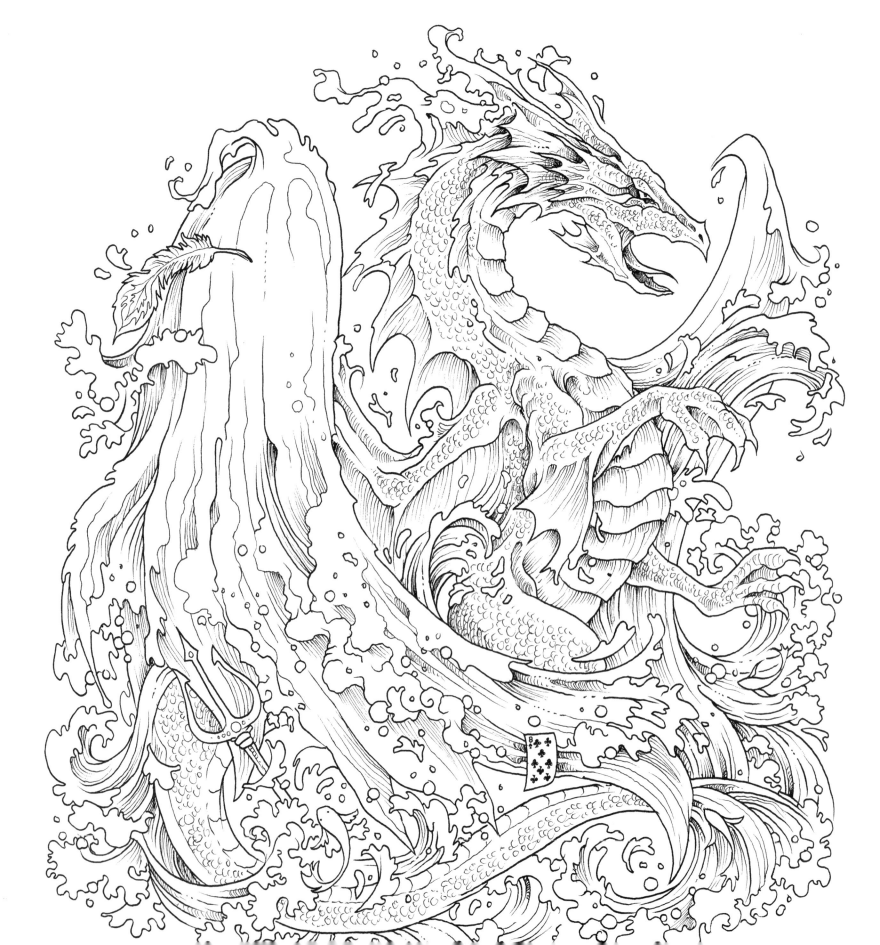

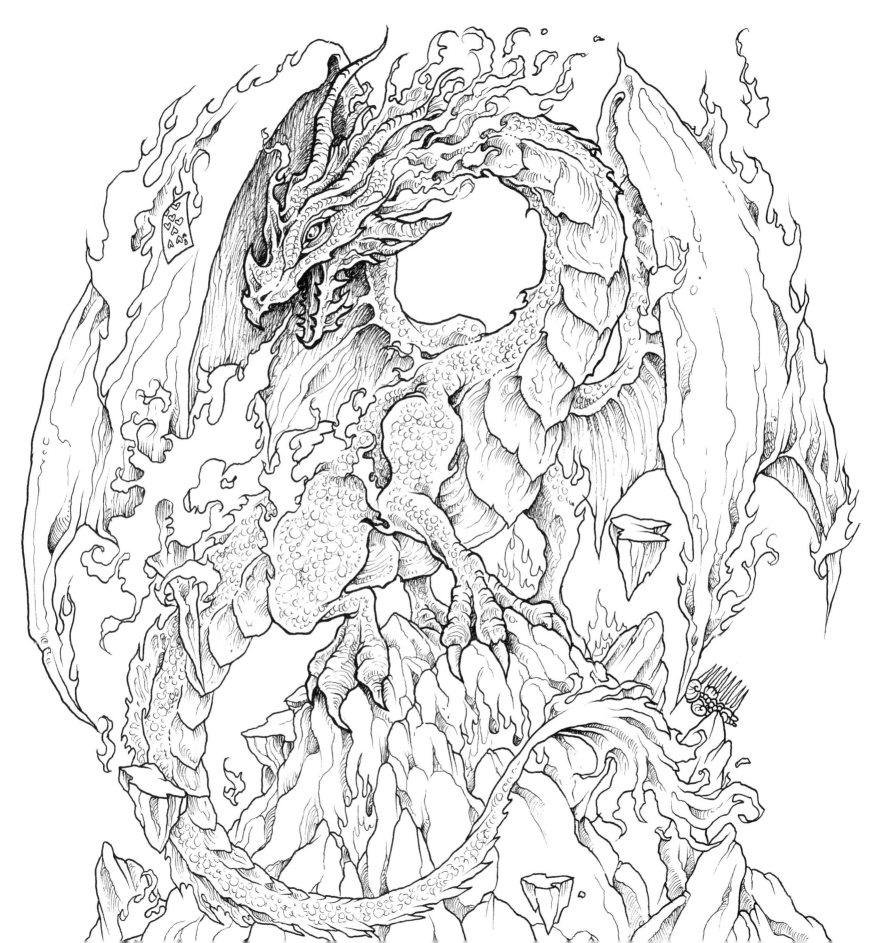

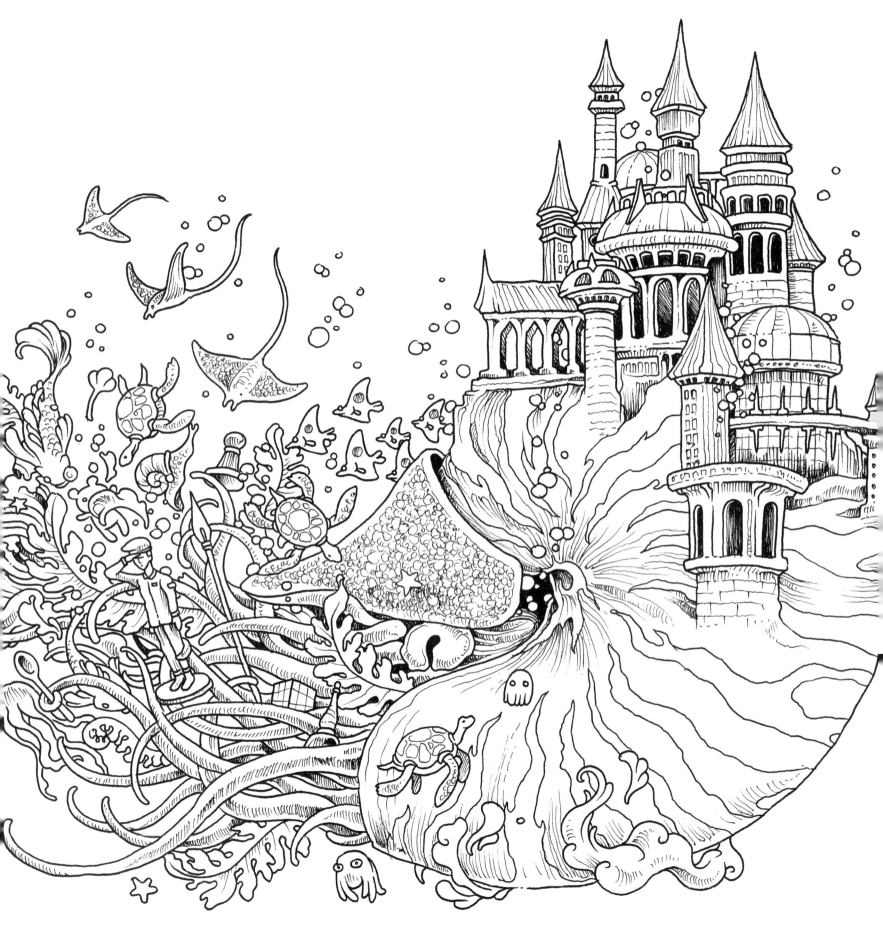

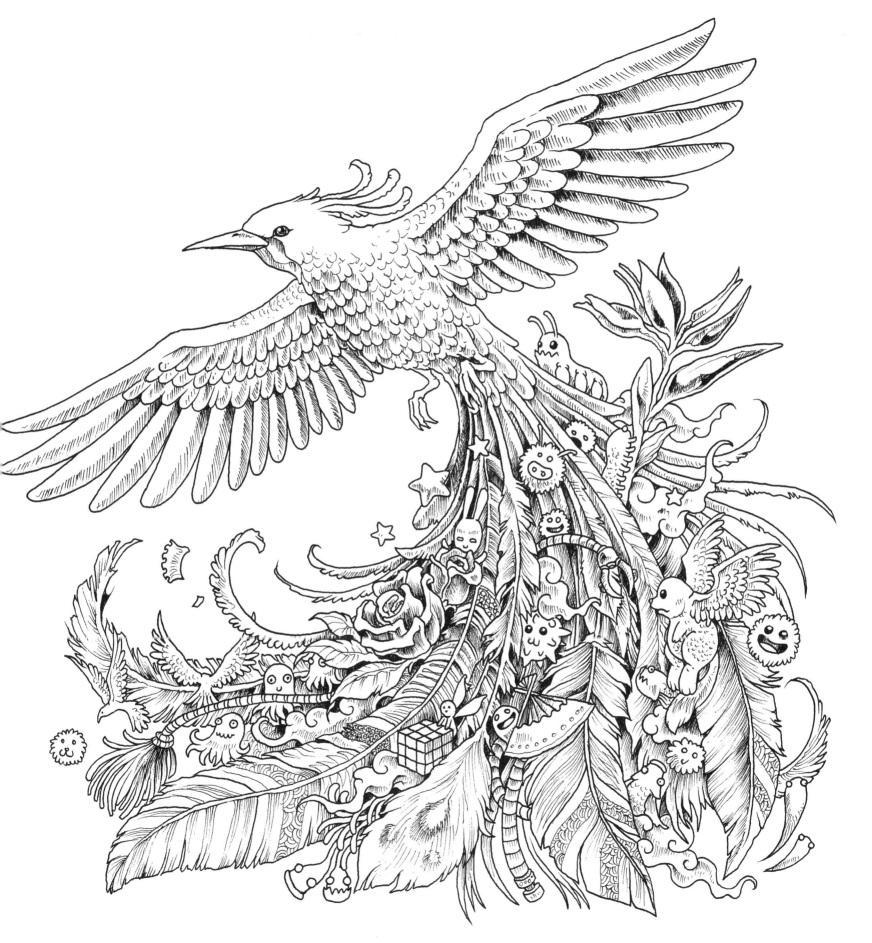

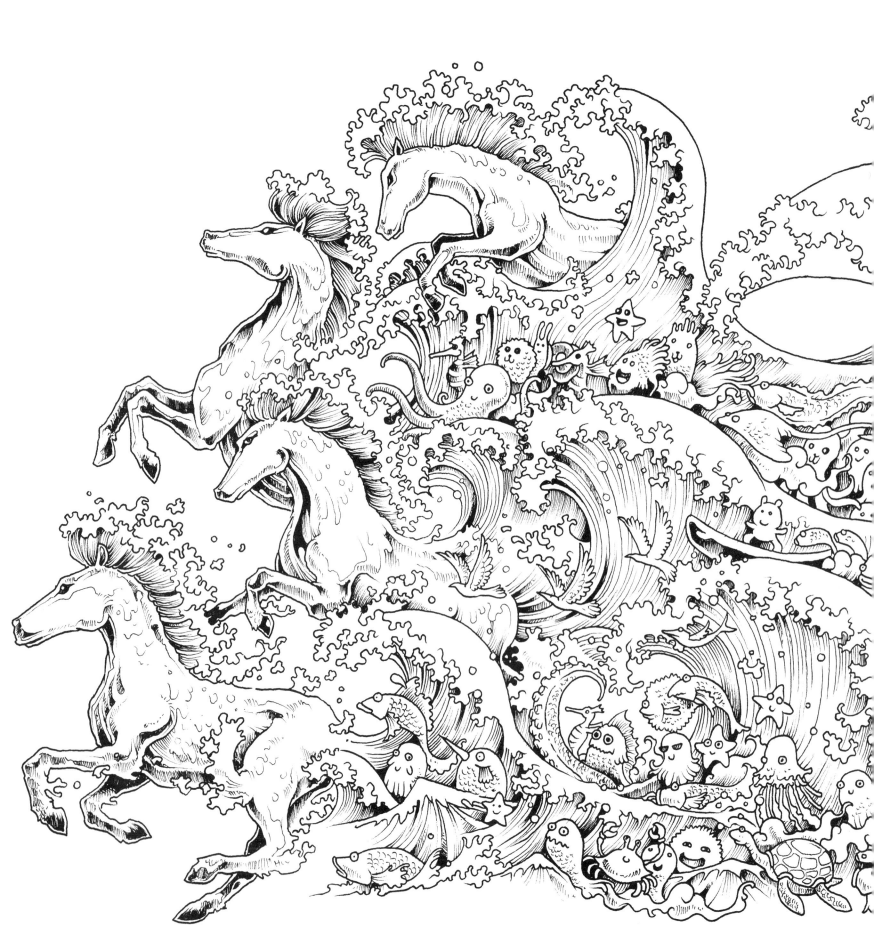

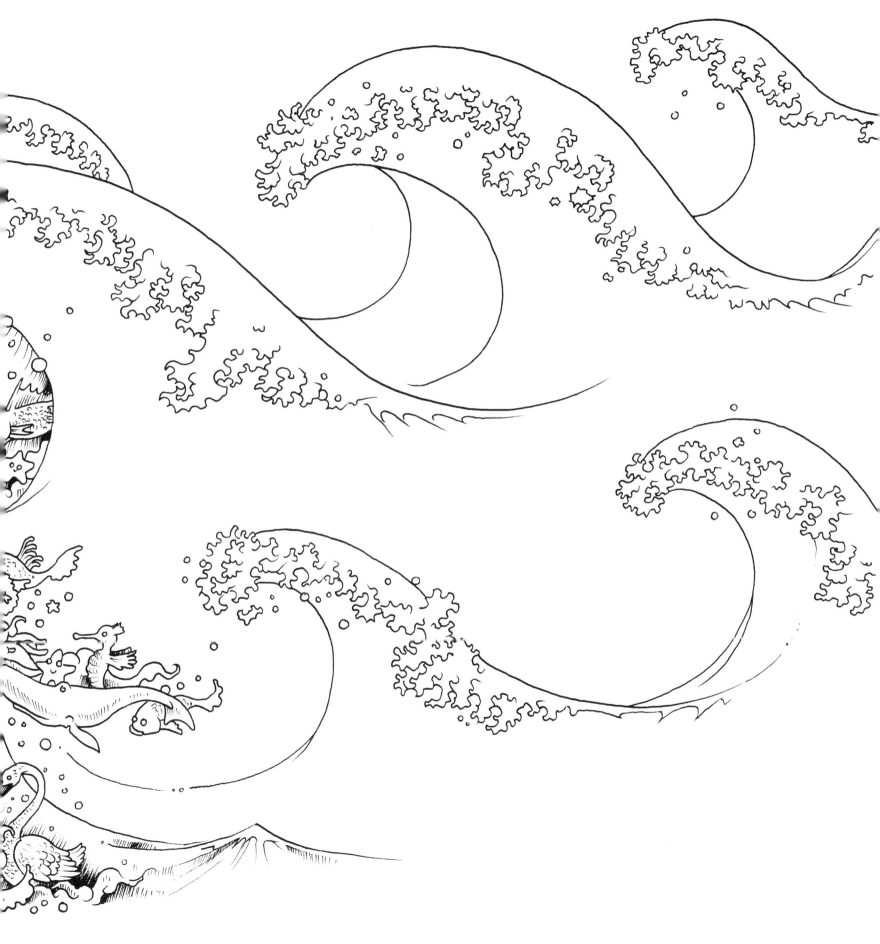

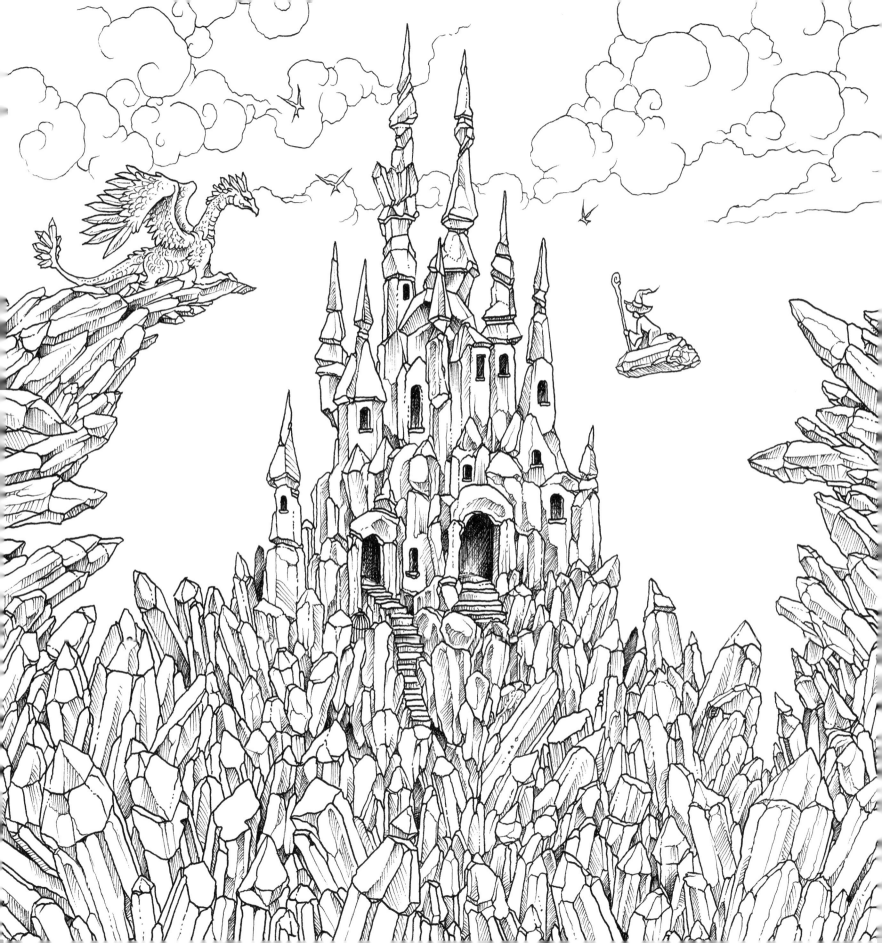

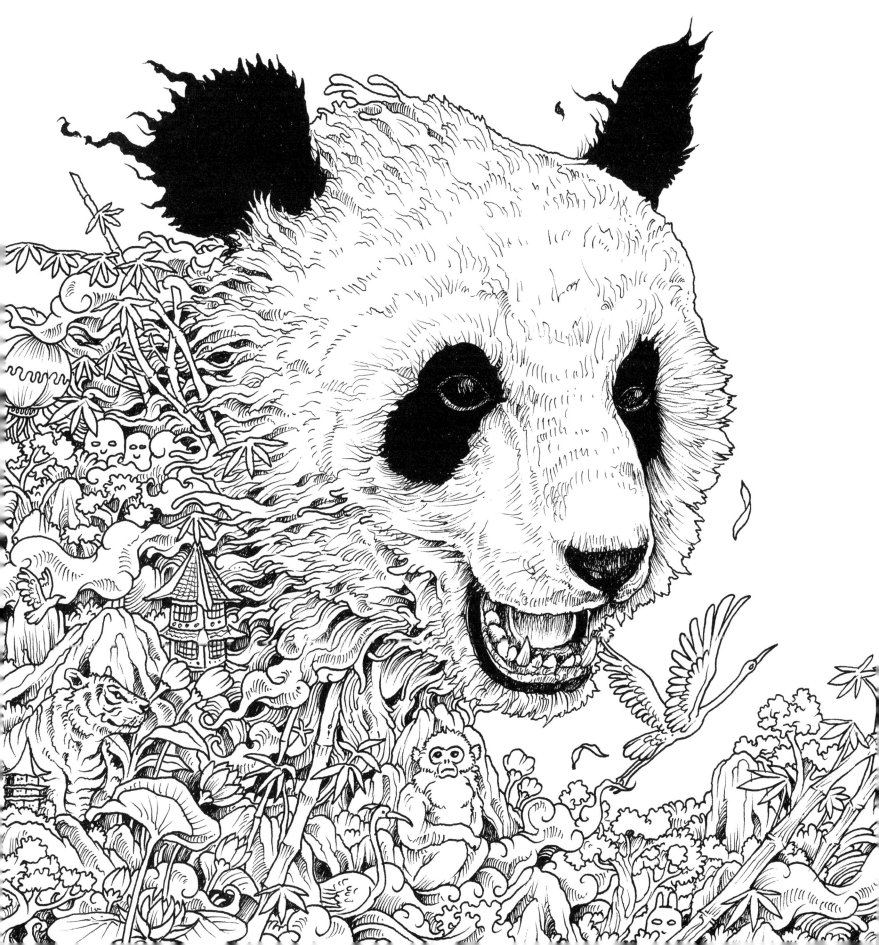

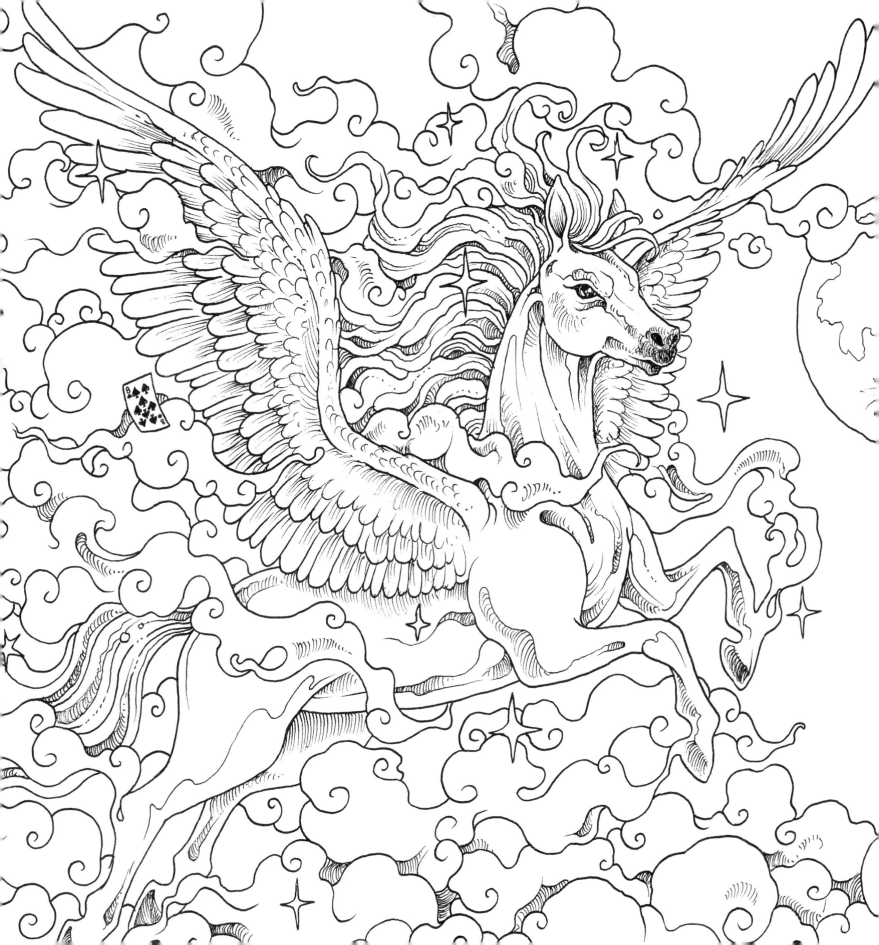

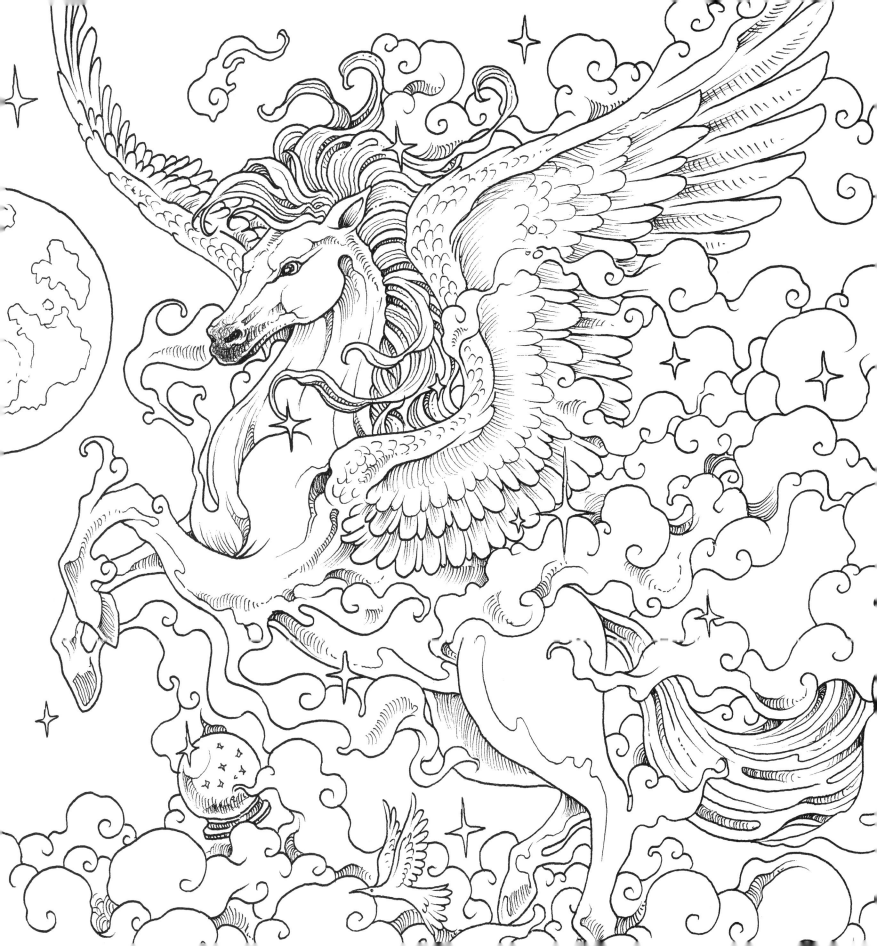

Illustrated by Kerby Rosanes

Edited by Zoe Clark
Designed by Derrian Bradder
Cover designed by John Bigwood
Cover images coloured by
Lauren Farnsworth and Nadia Mejri

With special thanks to Harry Thornton

First published in Great Britain in 2021 by LOM ART, an imprint of Michael O'Mara Books Limited,
9 Lion Yard, Tremadoc Road, London SW4 7NQ

The material in this book previously appeared in *Animorphia: An Extreme Colouring and Search Challenge,*
Imagimorphia: An Extreme Colouring and Search Challenge, Mythomorphia: An Extreme Colouring and Search Challenge,
Fantomorphia: An Extreme Colouring and Search Challenge, Geomorphia: An Extreme Colouring and Search Challenge,
and *Wondermorphia: An Extreme Colouring and Search Challenge.*

W www.mombooks.com/lom f Michael O'Mara Books 🐦 @OMaraBooks 📷 @lomartbooks

A CIP catalogue record for this book is available from the British Library.

ISBN: 978-1-912785-64-3

1 3 5 7 9 10 8 6 4 2

This book was printed in China.

MIX
Paper from
responsible sources
FSC® C010256